American Museum of Natural History

THE OFFICIAL GUIDE

**American Museum of Natural History, New York,
in association with
Scala Publishers, London**

SCA

AMERICAN MUSEUM OF NATURAL HISTORY

© 2001, 2007 American Museum of Natural History

First published in 2001 by Scala Publishers Ltd
Northburgh House, 10 Northburgh Street
London EC1V 0AT

ISBN: 978-1-85759-264-1

Designed by Roger Daniels

Production: Scala Publishers Ltd
Northburgh House
10 Northburgh Street
London EC1V 0AT

Printed and bound in China

10 9 8 7 6 5 4

Library of Congress Control Number: 2001130370

Title page illustration:
The Orion Nebula. Rendering by Digital Galaxy
Project, AMNH/San Diego Supercomputer Center
(SDSC): Carter Emmart, Erik Wesselak, Jon Genetti,
Dave Nadeau, Greg Johnson

PHOTOGRAPH CREDITS

Jackie Beckett/AMNH: 15 (top), 16 (bottom), 17 (top), 18 (with
D. Finnin), 19 (top, with D. Finnin), 19 (bottom), 20 (with C. Chesek,
D. Finnin), 21 (with D. Finnin), 22 (top), 25 (top, with D. Finnin), 31
(bottom, with D. Finnin), 32 (with C. Chesek), 34 (right, with D.
Finnin), 35 (bottom), 45 (top), 47 (bottom), 51 (top, with D. Finnin,
C. Chesek), 51 (bottom, with C. Chesek), 55 (top, with C. Chesek),
57 (bottom)
Ingrid Buntschuh: 43 (bottom)
Meg Carlough/AMNH: 56
Craig Chesek/AMNH: front cover, 10, 13 (with D. Finnin), 20
(with J. Beckett, D. Finnin), 22 (bottom), 31 (top), 32 (with J.
Beckett), 33 (with D. Finnin), 38 (bottom), 42, 43 (top, with D.
Finnin), 51 (top, with D. Finnin, J. Beckett), 51 (bottom, with J.
Beckett), 53 (with D. Finnin), 55 (top, with J. Beckett)
Fred Conrad: 17 (bottom right)

Denis Finnin/AMNH: 9, 11, 13 (with C. Chesek), 16 (top), 18
(with J. Beckett), 19 (top, with J. Beckett), 20 (with J. Beckett, C.
Chesek), 21 (with J. Beckett), 25 (top, with J. Beckett), 27 (top), 28,
31 (bottom, with J. Beckett), 33 (with C. Chesek), 34 (left; right,
with J. Beckett), 36 (bottom), 37, 38 (top), 39 (left and right), 41, 43
(top, with C. Chesek), 44, 45 (bottom), 46, 47 (top), 49, 50 (top and
bottom), 51 (top, with C. Chesek, J. Beckett), 52, 53 (with C.
Chesek)
Lynton Gardiner: 29
Roderick Mickens/AMNH: 4, 6, 30 (bottom), 40, back cover
Ken Regan/Camera 5: 25 (bottom), 30 (top)
John Bigelow Taylor: 35 (top)
A. Troncale/Department of Library Services: 57 (top)
Department of Library Services/AMNH Photo Studio: 7, 14,
15 (bottom), 17 (bottom left), 23, 24, 26, 27 (bottom), 36 (top), 54,
55 (bottom)

Contents

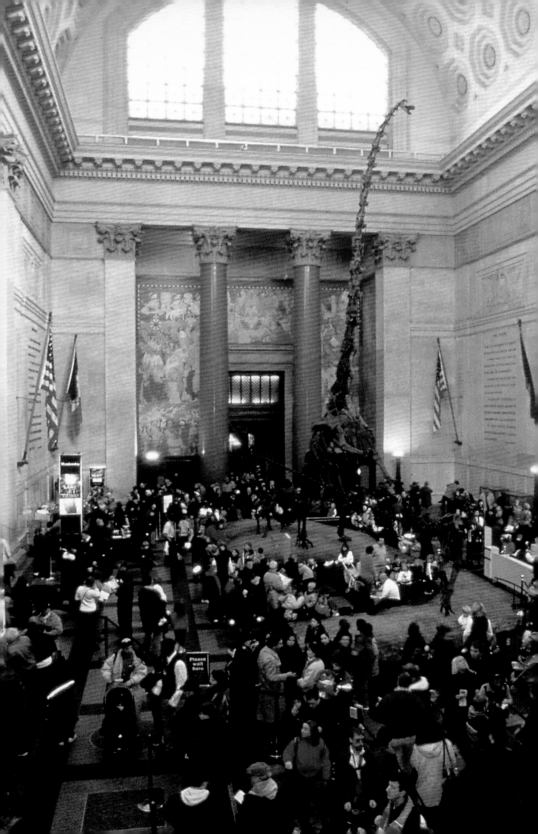

Letter from the President

Welcome to the American Museum of Natural History, truly a "Museum for the 21st Century."

For generations, the Museum has been a place of wonder and discovery for people of all ages. Founded in 1869 by a group of passionate and committed private citizens, the American Museum of Natural History began its story with a modest collection of specimens in need of a permanent home. More than 130 years later, the Museum is indisputably one of the world's greatest museums, educational resources, and scientific and cultural institutions.

With 25 interconnected buildings on Manhattan's Upper West Side, the Museum is home to more than 200 working scientists, a world-renowned collection of more than 30 million specimens and cultural artifacts, one of the largest natural history libraries in the Western Hemisphere, and numerous classrooms, auditoriums, and other education spaces. Most notable for the visitor are the Museum's 46 permanent exhibition halls, beloved by young and old. These halls explore the natural world around us, the universe beyond, and the cultures of humanity. Each year, the Museum acts as a trusted guide to approximately four million visitors, helping people to enrich their understanding of science and culture and to develop a deeper sense of humanity's place in the larger scheme of life.

The American Museum of Natural History is more than a cultural and educational institution, however; it is an active center of cutting-edge scientific research. The Museum supports dedicated research programs in molecular biology, genomics, and astrophysics, along with extensive work in the natural sciences, anthropology, and conservation. The Museum acts as host to many of the most prominent and influential scientists, policy makers, and commentators on topics of urgent public interest and concern, presenting award-winning topical exhibitions, pioneering science-education programs, and fostering lifelong learning for a broad range of audiences.

The Museum offers a unique window on scientific exploration and discovery that is inspiring, provocative, relevant to our everyday lives, and critical to an appreciation of the world around us. I invite you to begin your journey through the Museum, to awaken the naturalist within you, and to discover the glorious and fascinating richness of the world and the universe in which we live.

ELLEN V. FUTTER
President

The Theodore Roosevelt Rotunda.
This hall's *Barosaurus* is the world's highest
freestanding mount of a dinosaur.

Introduction

Since its founding in 1869, the American Museum of Natural History has advanced its global mission to discover, interpret, and disseminate information about human cultures, the natural world, and the universe. Long celebrated for the depth of its collections and the scope and beauty of its exhibition halls, the Museum has continually been at the forefront of scientific research, sharing its discoveries with the public through a wide-reaching program of education and exhibition. Approximately four million visitors come to the Museum each year to explore 25 buildings and 46 permanent halls, on a journey from the outer edges of the observable universe to the inner core of Earth to the great diversity of life on our planet.

History

The Museum was founded by Albert Smith Bickmore (1839–1914), after his proposal for a natural history museum in New York City won the support of such prominent New Yorkers as William E. Dodge, Jr., Theodore Roosevelt, Sr., Joseph Choate, and J. Pierpont Morgan. These men shared with

Above: **The Museum's 77th Street entrance in 1907**
Opposite: **A young visitor in** *The Butterfly Conservatory*

Bickmore, a professor and one-time student of noted Harvard zoologist Louis Agassiz, the vision of a great center for research and teaching in the natural sciences and anthropology, an institution where both scientists and the general public could come to learn.

The Museum's first exhibits were displayed in the Central Park Arsenal, the Museum's original home, on the eastern side of Central Park. When the Museum outgrew the Arsenal, Calvert Vaux, one of the designers of Central Park, and J. Wrey Mould planned the present Museum on a large swampy farmland site known as Manhattan Square, which was donated by the city. The first building was started in 1874, with United States President Ulysses S. Grant laying the cornerstone, and completed in 1877.

The decades to follow marked a golden age of exploration, as Museum scientists made expeditions to such far-flung locations as Mongolia, Siberia, the Congo, and the North Pole. During this era Museum scientists fundamentally reshaped important fields such as anthropology and evolutionary biology, in addition to amassing great collections. At the same time, the institution's facilities also grew: the Romanesque Revival 77th Street façade was completed in the 19th century, and major additions were made in the 1920s and 1930s, including the Theodore Roosevelt Memorial with its grand entrance on Central Park West and the original Hayden Planetarium.

With much of its physical structure established, the Museum expanded beyond its early halls—Northwest Coast Indians, fossils, and mammals—to add displays on birds, reptiles, gems and minerals, human evolution, and cultural groups from around the world. Acknowledging the crucial role of educational programming and exhibitions at the Museum, the institution also created an education wing and two special-exhibition galleries to complement its broad array of permanent halls. In 1999, the Museum's expansion extended to its scientific facilities as well, with the opening of the C. V. Starr Natural Science Building. The Starr Building offers cutting-edge laboratories and equipment for scientific staff as well as new collections space.

This history of innovative research, education, and exhibition continues today with the presentation of topical special exhibitions and ongoing renovations and expansion. Since 1994, the Museum has created 17 new halls, from the fossil halls—which include the Museum's world-renowned dinosaurs—to the Spitzer Hall of Human Origins. Most notably, the Museum created the Frederick Phineas & Sandra Priest Rose Center for Earth and Space. A groundbreaking new facility that opened in 2000, the Rose Center combines state-of-the-art architectural and exhibit design with pioneering scientific research and technological innovation in a popular and critically acclaimed new resource.

Science

With a scientific staff of more than 200, including more than 40 curators, the Museum supports research divisions in Anthropology, Paleontology, Invertebrate and Vertebrate Zoology, and the Physical Sciences. These scientific divisions oversee a permanent collection of over 30 million specimens and cultural artifacts, which includes the world's largest collection of vertebrate fossils, more than 500,000

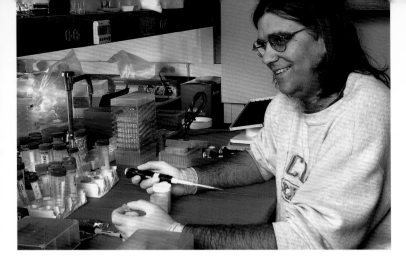

A Museum curator in the Molecular Systematics Laboratories

anthropological objects, and the world's most important research collection of amber fossils. In addition to its vast on-site resources, one of the Museum's primary sources of scientific knowledge has been the thousands of field expeditions conducted by Museum scientists to every continent since 1887. This tradition continues today with more than 100 field projects each year in locations such as Chile, China, Cuba, Madagascar, Mongolia, New Guinea, and Vietnam.

The Museum continues to expand its leadership in many fields, including New World archaeology and cultural anthropology; Earth sciences and meteoritics, augmented by the new Department of Astrophysics established in 1999; and systematic biology, the mapping of evolutionary relationships and classification of the world's species.

The Museum is pioneering efforts to deepen our knowledge of the myriad species that inhabit this planet and to understand the history of life, an especially important initiative in light of the global losses of plant and animal species. In 1993 the Museum launched the interdisciplinary Center for Biodiversity and Conservation (CBC) to address environmental threats to Earth's biological systems. The CBC coordinates partnerships between the Museum's scientific staff and national and international organizations to oversee research, field projects, and training programs, creating a wealth of data and resource materials for scientists and governmental agencies around the world concerned with conservation efforts and policies.

The Museum's vast research experience in comparative biology has put the institution at the forefront of a new era of scientific research in the field of genomics. Genomics is the identification, study, and analysis of the sequence of proteins that constitutes an organism's DNA. Through the Molecular Program, founded in 1990, the Museum has performed groundbreaking sequencing and analysis of DNA of both living and extinct organisms, enabling Museum scientists to gain new insights into the patterns of evolution, the relationships among species, and the history of extinction and endangerment. The Museum's growing research program in nonhuman comparative genomics, which is conducted in the state-of-the-art Molecular Systematics Laboratories and is the foundation for the Sackler Institute for Comparative Genomics, demonstrates the institution's ongoing role

9

The *Paleontology of Dinosaurs* Moveable Museum

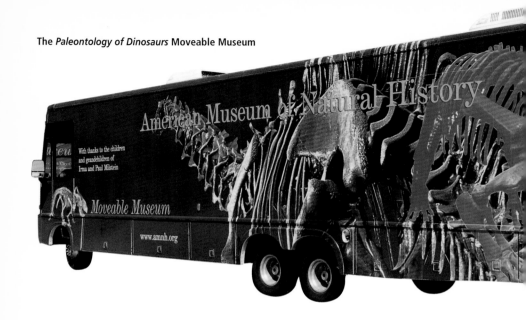

in making the latest discoveries on the frontiers of science.

The Museum convenes major scientific conferences, for both the scientific community and the general public, on topics of vital public interest relating to key areas of the Museum's research and emerging fields. Recent conferences hosted by the Museum include *Stellar Collisions, Mergers, and Their Consequences*, *Sequencing the Human Genome: New Frontiers in Science and Technology*, and *Assembling the Tree of Life: Science, Revelance, and Challenges*, which addressed the pattern of relationships that links all Earth's species.

The Museum is committed to training and supporting the next generation of scientists. Its postdoctoral training program is one of the oldest and largest of its kind in the world. Each year, dozens of the most promising young scientists pursue original research at the Museum and in the field, in collaboration with Museum scientists. With

such collaborations and training, the Museum is helping to ensure the future of the natural sciences worldwide.

Education

The Museum's research provides the foundation for its educational programs, which focus on increasing science literacy among both adults and children, deepening the public understanding of issues that affect the future of the planet and its inhabitants, and providing a forum for exploring cultural diversity. In a world increasingly shaped by technology and science, the Museum recognizes that people must have access to scientific knowledge in order to be full participants in today's society. Toward this end, the Museum advocates the concept of lifelong learning. The Museum develops and presents programs that engage children and adults of all ages, fostering a love of nature and awakening the scientist in all.

On-site, the Museum is visited by more than 400,000 children in school groups annually, many of them participating in formal education programs. In addition, more than 40 free after-school courses are offered to complement and build upon what high-school students learn in the classroom. In the High School Science Research program, students are paired with Museum scientists to work on long-term projects.

Extending beyond the many on-site programs available, in 1992 the Museum launched the highly popular Moveable Museum program. Moveable Museums are converted and customized 34-foot-long Winnebagos outfitted as exhibition spaces with specimens, interactive computers, and exhibits that travel to schools, community centers, parks, and street fairs.

Education for young people also includes the Museum Education and Employment Program and Middle School Investigations, in which young adolescents begin a relationship with the Museum that lasts through high school and beyond. In order to extend its educational mission to an even broader audience, the Museum took a leadership role in national science education with the opening in 1997 of the National Center for Science Literacy, Education, and Technology. The National Center uses both new and traditional technology and media to connect people around the world to science in the

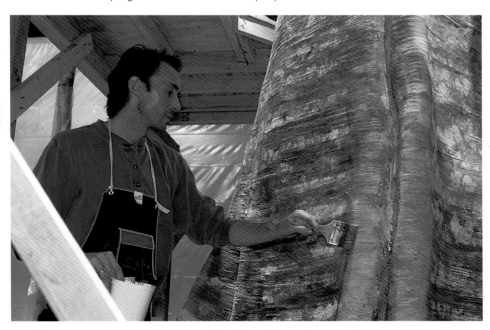

An exhibition preparator painting a tree trunk for the rain forest diorama in the Hall of Biodiversity

11

laboratory, in the field, and even in outer space.

In addition to its many science-related programs, the Museum's Global Weekends illuminate the heritage of the world's cultures, from Native American to Latino to Asian/Pacific, and include the annual Kwanzaa festival, Living in America series, and Black History Month programs. The Margaret Mead Film & Video Festival, held each fall since 1977, is the longest-running annual festival of documentary and ethno-graphic film and video in the country.

Exhibition

Exhibitions are the Museum's most powerful tool for sharing scientific knowledge and discovery with the general public. Cutting-edge exhibition halls, such as the Rose Center for Earth and Space and the reno-vated fossil halls, bring the latest research to the visitor through multimedia installations that supplement the renowned specimens and accommodate updated information. Complementing its newer installations are the Museum's classic halls, such as the Akeley Hall of African Mammals and the Hall of Northwest Coast Indians. These halls, with their dioramas, murals, and detailed installations, demonstrate the Museum's long history of beautiful and innovative exhibition techniques. In addition to being revolutionary for their time, the dioramas are widely renowned for combining true artistry with scientific accuracy.

Throughout the Museum's exhibits, the visitor finds examples of such artistry: the fossil hall murals and paintings of Charles R. Knight (1874–1953), depicting prehistoric

life in action; the enormous, realistically ren-dered models of planets in the Scales of the Universe at the Rose Center; and the Central African Republic rain forest diorama in the Hall of Biodiversity, featuring more than 500,000 leaves created by hand from molds made in the field. The Museum's displays combine groundbreaking technologies with traditional, timeless methods to interpret the work of its scientists.

The Museum also develops and presents a vigorous schedule of special exhibitions that explore world cultures, current scientific issues, and the natural sciences. Recent highlights include: *Petra: Lost City of Stone; Einstein; Vietnam: Journeys of Body, Mind & Spirit; The Genomic Revolution; Fighting Dinosaurs: New Discoveries from Mongolia; Body Art: Marks of Identity; Darwin; Lizards and Snakes: Alive!;* and the extraordinarily popular annual *Butterfly Conservatory: Tropical Butterflies Alive in Winter*. In addi-tion to its large-scale special exhibitions, the Museum offers an ongoing series of smaller exhibitions in its Akeley Gallery, usually focusing on photography. Special exhibitions often travel to other museums across the country and around the world, allowing the Museum to share its treasures and insights with a wider public, broadening the institu-tion's impact and reach.

The Museum is dedicated both to acquiring scientific knowledge and to sharing that learning with the broadest audience possible. It is through the suc-cessful combination of science, education, and exhibition that the Museum expands our understanding of ourselves and our environments, from the cosmic to the microscopic.

Fossil Halls

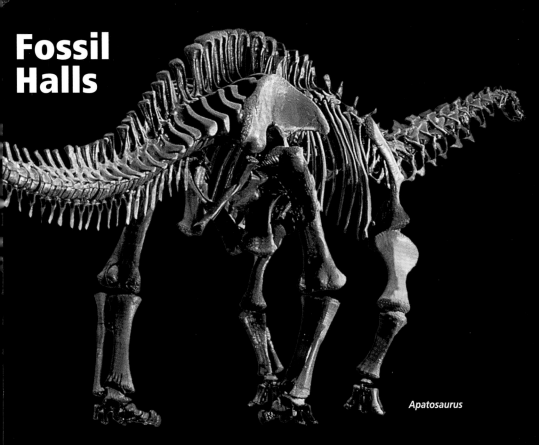

Apatosaurus

One of the premier attractions in New York City is the Museum's series of fossil halls, including its two famed dinosaur halls. The Museum is home to the world's largest collection of vertebrate fossils, totaling nearly one million specimens. More than 600 of these specimens, nearly 85 percent of which are real fossils as opposed to casts, are on view. After a massive renovation which culminated in the halls' reopening between 1994 and 1996, the fossil halls now stand as a continuous loop on the fourth floor, telling the story of vertebrate evolution. Unlike most fossil exhibits, which are arranged in chronological order, the Museum's fossil halls display the specimens according to evolutionary relationships, dramatically illustrating the complex branches of the tree of life, in which animals are grouped according to their shared physical characteristics. Such relationships are determined through a method of scientific analysis called cladistics, which the Museum helped pioneer. The halls' renovation also allowed for new scientific interpretations of favorite displays, as well as the restoration of the fourth floor to its original architectural grandeur.

HALL OF
Saurischian Dinosaurs

The earliest-known dinosaurs appeared about 230 million years ago; their fossils have been found on every continent. They dominated the land until about 65 million years ago, when an episode of extinction eliminated the nonavian dinosaurs as well as many other animals and plants, both on the land and in the seas. Possible causes for these extinctions include the impact of an extra-terrestrial object or a major, global peak in volcanic activity.

The American Museum of Natural History is home to the single largest collection of dinosaur fossils in the world, with more than 100 specimens featured in its halls. The Hall of Saurischian Dinosaurs examines the branches of dinosaurs whose common ancestor had a grasping hand, with fingers that differed in size and shape. This hall features some of the Museum's most beloved and terrifying specimens, including *Tyrannosaurus rex* and *Apatosaurus*. Both of the displays have been revised to represent new scientific thinking: *T. rex*, once presented upright, is now positioned in a low, stalking pose with its tail in the air, while *Apatosaurus*—previously known as *Brontosaurus*—has a new skull, additional neck bones, and a longer, elevated tail. Also featured in this hall is the group of dinosaurs—maniraptors—that includes on its evolutionary branch living birds.

Above:
**Tyrannosaurus rex
in foreground**

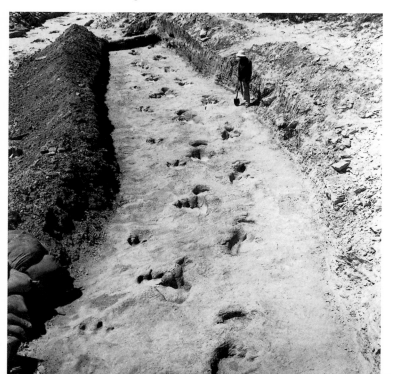

Left: **The Glen Rose Trackway, a series of fossilized dinosaur footprints left more than 100 million years ago at the edge of a lagoon in what is now Texas**

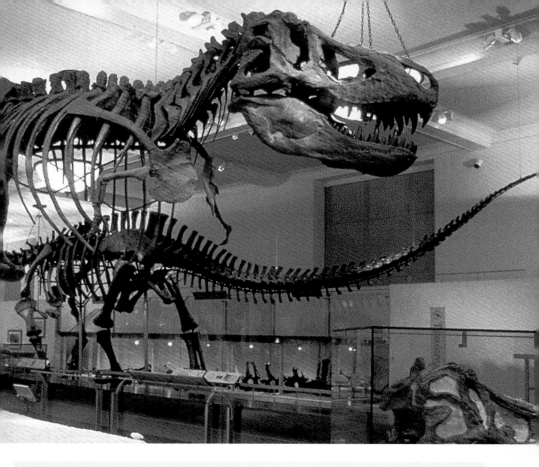

Dinosaur Eggs

As far as scientists know today, all dinosaurs reproduced by laying eggs. Until the 1980s, discoveries of fossilized eggs and bones of young dinosaurs were extremely rare, but dinosaur eggs are now known from several continents, and fossils of hatchlings, juveniles, and adults have been found for most major groups. Determining the exact species to which the eggs belong is difficult, however, since only a few dinosaur embryos have been found inside the fossil eggs. In 1993, the Museum team working in collaboration with the Mongolian Academy of Sciences discovered the first dinosaur embryos, from eggs preserved in the Gobi Desert (see p. 17).

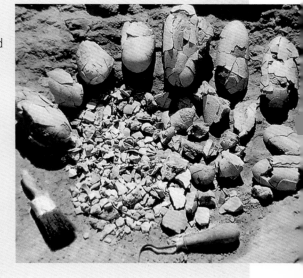

HALL OF
Ornithischian Dinosaurs

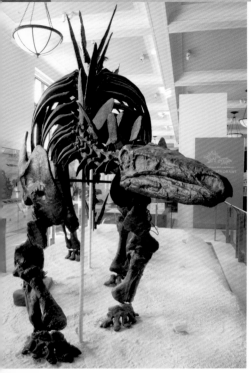

Above: Stegosaurus Below: Triceratops

The Hall of Ornithischian Dinosaurs examines the branches of dinosaurs that possess a backward-pointing pubis bone. Additional features found within the ornithischians include inset tooth rows forming cheeks and the uneven covering of enamel on the teeth. It is believed that both these traits allowed for increased efficiency in holding and chewing food. This hall includes such favorites as *Stegosaurus*, a 140-million-year-old dinosaur with distinctive rows of plates down the center of its back and large spikes in the end of its tail (along with a cast of the first juvenile *Stegosaurus* ever found) and the 65-million-year-old horned and shield-headed dinosaur *Triceratops*. This specimen has a partly healed injury on its three-horned skull, possibly caused by another *Triceratops*. On view nearby are the "mummy" specimens of *Edmontosaurus* and *Corythosaurus*, whose fossils have preserved large areas of skin impressions, allowing us a rare glimpse of what these creatures might have looked like alive.

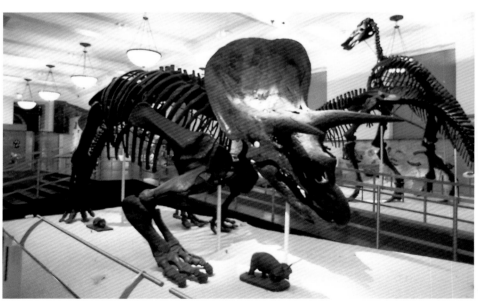

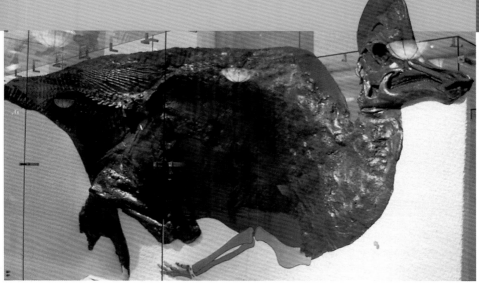

Gobi Desert Expeditions

From 1921 to 1930, Roy Chapman Andrews (1884–1960) led the Museum's Central Asiatic Expedition through the Gobi Desert of Mongolia, making some of the world's most historic dinosaur finds. Since 1990, when the Mongolian Academy of Sciences invited the Museum to take part in a joint expedition to the Gobi, Museum scientists have returned annually to this important region.

In 1993 the expedition discovered Ukhaa Tolgod, the richest known Cretaceous fossil site on Earth. On view throughout the dinosaur halls are discoveries from both the Museum's early and current Gobi expeditions. One recently unearthed Gobi specimen is that of an *Oviraptor*, found in 1994, which died while nesting on its eggs, providing the first direct evidence of nesting behavior in dinosaurs.

Roy Chapman Andrews in the field during the Central Asiatic Expedition (1921–30)

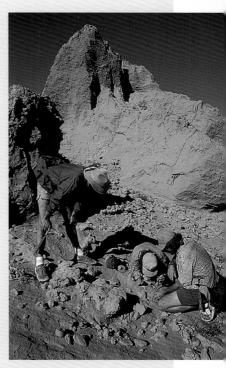

A recent Gobi expedition by Museum scientists

The **Lila Acheson Wallace Wing of Mammals and Their Extinct Relatives**—which includes the Hall of Primitive Mammals and the Paul and Irma Milstein Hall of Advanced Mammals—tells a fascinating tale of great diversification, sudden extinctions, and the forces that determine the success and obliteration of life. Mammals evolved at nearly the same time as the first dinosaurs, and the roots of the mammalian line reach back almost 300 million years. Some of the very early relatives of mammals, creatures resembling enormous lizards with giant fins along their backs, actually lived millions of years before the dinosaurs and dominated the land. Most of them then became extinct, and during the age of dinosaurs none of the mammals got much larger than small rodents. After the extinction of the large dinosaurs, the great diversity of mammals arose that we see today, including both primitive and advanced species.

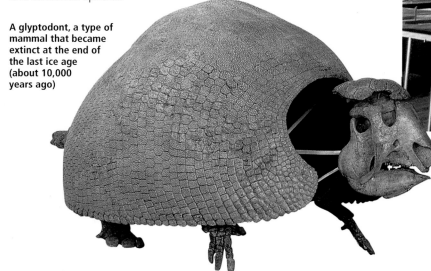

A glyptodont, a type of mammal that became extinct at the end of the last ice age (about 10,000 years ago)

The Hall of Primitive Mammals traces the lower branches of the evolutionary tree of mammals, including such features as the synapsid opening in the skull (a large hole behind the eye socket for muscles that extend to the jaw, found also in early relatives of mammals), the three middle ear bones (used to classify all mammals), and the placenta. These traits correspond to eating, hearing, and reproduction functions, and each represents an evolutionary branch. Included in this hall are monotremes, marsupials, sloths, and armadillos. Some living animals from these groups, such as the platypus, have so many primitive features that they are called "living fossils."

Above right:
Exhibit pinpointing evolutionary features

18

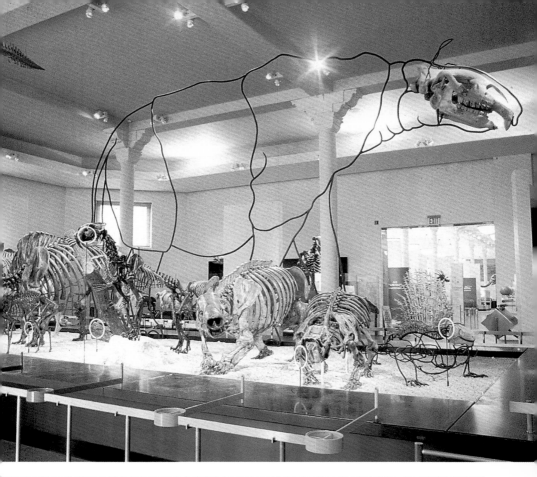

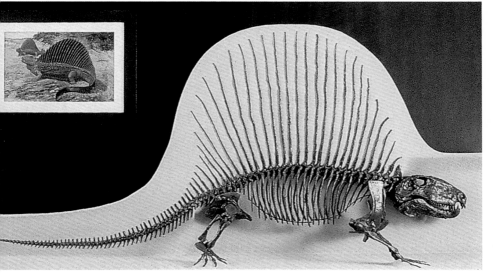

Dimetrodon, a distant relative of mammals that lived about 280 million years ago

PAUL AND IRMA MILSTEIN HALL OF
Advanced Mammals

The Museum's tradition of excavating, studying, and exhibiting fossil mammals has an even longer and more illustrious history than its work with dinosaurs. The Museum's first expedition to search for such fossils was launched in 1891, and in 1895, before its scientists had found a single dinosaur, the Museum opened a full-scale hall of fossil mammals. This original hall, which has displayed such specimens continuously since then, now features advanced mammals with such traits as hoofs and eye sockets near the snout, in addition to those traits featured in the Hall of Primitive Mammals. A wide range of animals is represented along these evolutionary branches, including cats, seals, bears, primates, horses, whales, and elephants, along with their extinct relatives. Up until about 10,000 years ago, mammoths, mastodons, saber-toothed cats, camels, and giant ground sloths roamed across North America. Then, an episode of extinction wiped all those animals out. The cause of this wave of extinction is unclear, but possible explanations include dramatic climate changes at the end of the last ice age, hunting by humans, and infectious disease.

Opposite:
Mammoth

Evolution of Horses

An especially illuminating exhibit in this hall is the series of horse fossils, which demonstrates both previous and current views of evolution. The first series reflects the classic view, showing a linear progression of skeletons from smallest to largest, with a trend toward fewer toes and longer teeth. The second, more modern series reflects the more complex relationships determined through cladistics—the grouping of animals according to shared, specialized characteristics. This second display shows that some later horses are actually smaller than earlier ones, and that other later horses still had three toes.

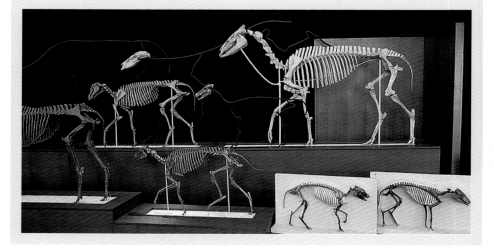

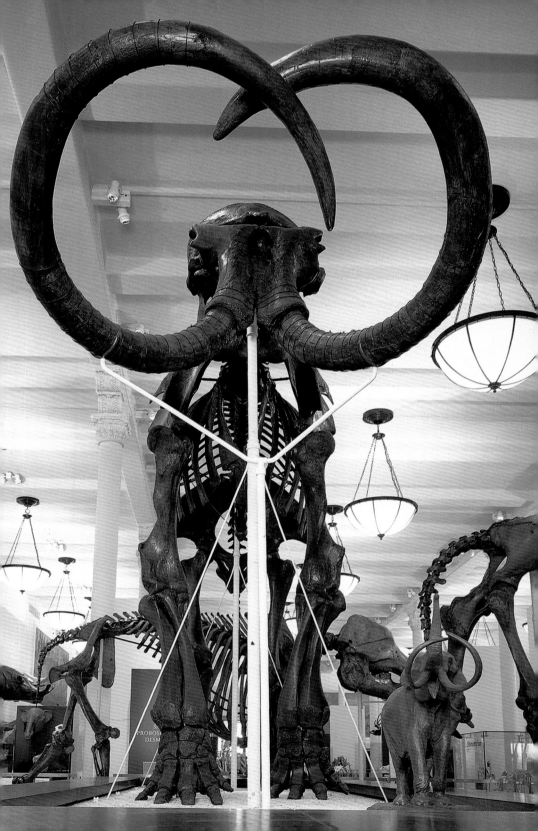

Vertebrate Origins

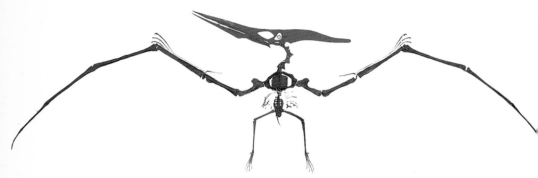

Immediately adjacent to the Miriam and Ira D. Wallach Orientation Center, which includes the video presentation *The Evolution of Vertebrates*, the Hall of Vertebrate Origins tells the story of the burgeoning of vertebrates through the oceans and onto land, an evolutionary sequence stretching back more than 500 million years. The development of some of the most basic, yet revolutionary, physical characteristics—the backbone, jaws, limbs, and the ability to reproduce without returning to the water—was key to the evolution of life on Earth and is examined in the Hall of Vertebrate Origins. The hall traces the evolution of such stunningly varied creatures as the first vertebrates to walk on land, the first vertebrates to live entirely on land, and the first flying vertebrates. Highlights include *Buettneria*, one of the earliest four-limbed animals; the massive armored early fish *Dunkleosteus*; the gigantic aquatic turtle known as *Stupendemys*; and *Pteranodon*, a flying reptile, or pterosaur, with a wingspan of 23 feet.

Above: Pteranodon

Below: Eryops

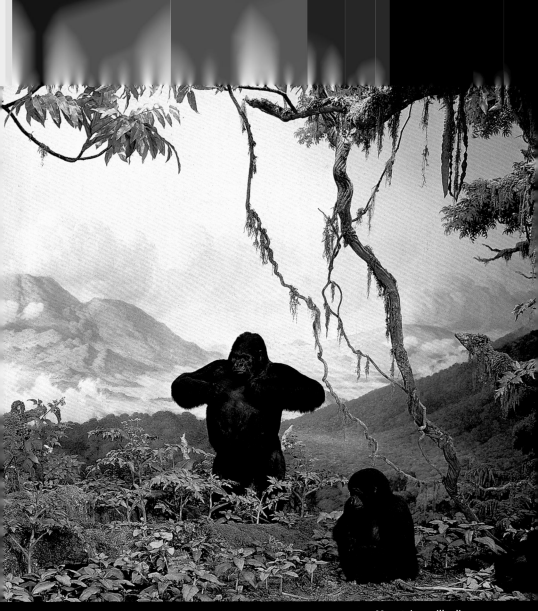

Mountain gorilla diorama

The Museum's mammal halls are among its most renowned and beloved. With precise depictions of geographical locations and the careful, anatomically correct mounting of the specimens, the Museum's dioramas are windows onto a world habitats. Moreover, since many of the environments represented have been exploited or degraded, some dioramas preserve places and animals as they no longer exist. The visitor to these halls is able to travel not only across continents, but also, in some cases,

AKELEY HALL OF
African Mammals

Since its opening in 1936, the Akeley Hall of African Mammals has been considered one of the world's greatest museum displays. The hall is named after Carl Akeley (1864–1926), the explorer, conservationist, taxidermist, sculptor, and photographer who conceived of, designed, and collected for the hall. All the mammal dioramas in the Museum were created using his highly refined taxidermy and mounting techniques. The animals have been reconstructed with such scientific accuracy and detail that they appear astoundingly lifelike. Akeley's meticulous attention to veracity, which was applied to the plants, the painted backgrounds, and even the lighting in the dioramas, resulted in faithful and vivid reproductions of the worlds that he wanted to preserve.

The 28 dioramas in this hall, true works of art, depict some of the many animals and habitats of Africa, from the bongo and mandrill of the dense rain forests to the impala and elephant of the savanna. Carl Akeley had a lifelong devotion to the continent of Africa and the conservation of its beautiful wilderness areas. He traveled there many times, including three expeditions for the Museum. During his final expedition, he fell ill and died. He was buried in Albert National Park (now Virunga National Park), the first wildlife sanctuary in central Africa, which he had helped to establish. The mountain location of his grave is near the scene depicted in the gorilla diorama in this hall.

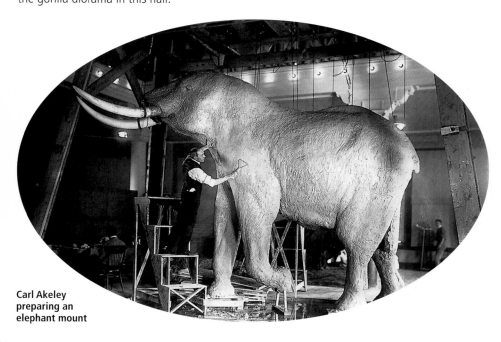

Carl Akeley
preparing an
elephant mount

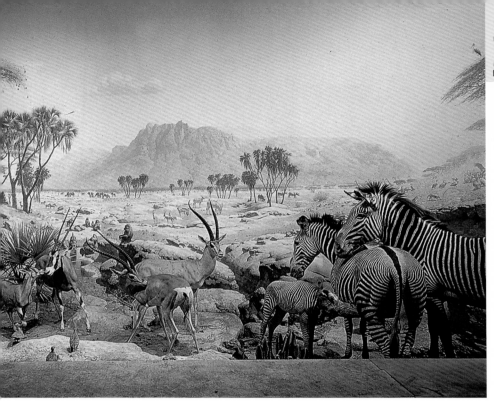

Above: Diorama of a water hole gathering. *Below:* Elephant exhibit in the center of the hall

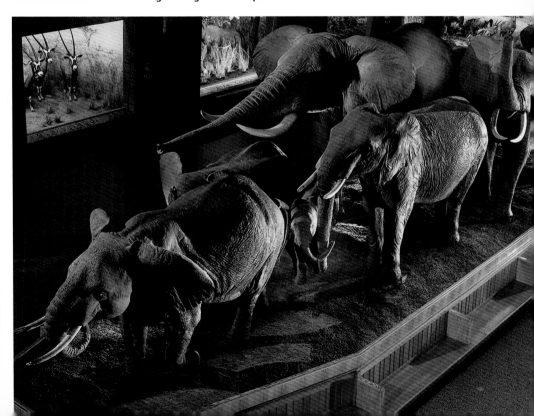

More than 25 Museum expeditions, ranging from Mexico to Ellesmere Island in the Canadian Arctic and from the Atlantic to the Pacific Oceans, produced the magnificent examples of North American mammals displayed in this hall.

James Perry Wilson (1889–1976), a master of artful illusion, painted the backgrounds for many of the dioramas at the Museum, including those in the Hall of North American Mammals. In addition to accurately capturing every detail, his paintings evoke the intangible feel of the places they depict. This is owed in part to Wilson's dizzyingly precise

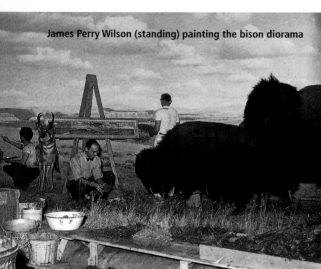

James Perry Wilson (standing) painting the bison diorama

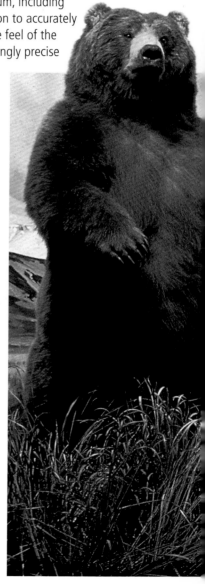

perspective, one of his signature qualities. In his dioramas the real materials of the foreground merge impeccably with the painted background, uniting the two- and three-dimensional into a seamless whole.

Creating these illusions involved a great deal of research. To prepare the bison diorama, Wilson traveled to Wyoming in 1938 with a scientific specialist and another artist. There Wilson made color sketches, took photographs, and collected specimens for the foreground of the scene. On his return he painstakingly reproduced the Wyoming plains on the curved walls of the diorama. Other dioramas in the hall feature bighorn sheep, two moose locked in combat, and watchful jaguars.

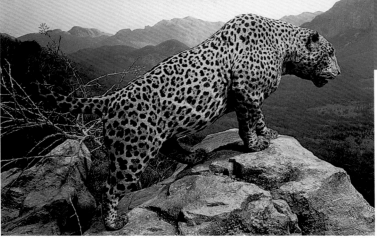

Jaguar diorama

Alaska brown
bear diorama

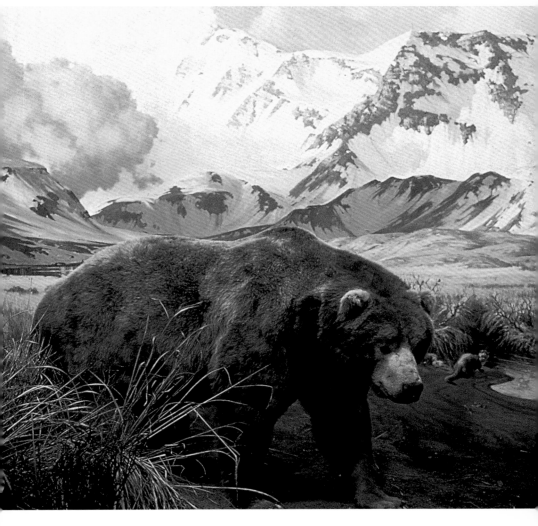

HALL OF
Asian Mammals

etween 1922 and 1928, Museum Trustee Arthur S. Vernay and British Colonel John C. Faunthorpe conducted six expeditions to collect animal specimens in India, Burma (now Myanmar), and Siam (now Thailand). The specimens were then donated to the Museum and formed the foundation for this hall, which opened in 1930.

The mounting of the animals in the Hall of Asian Mammals was overseen by James L. Clark using Carl Akeley's methods, and the hall's layout is similar to that of the Akeley Hall of African Mammals. As in the Akeley Hall, a group of elephants forms the centerpiece. These complementary exhibits allow the visitor to note the differences between the two types of elephant: the Asian elephant is generally smaller in size, with smaller ears and a higher forehead. The animals featured in this hall also include the water buffalo, gaur, leopard, and rhinoceros, and many represent species threatened by poaching and loss of habitat. Two examples of Asian mammals, the Siberian tiger and the giant panda, were among the animals relocated to the Endangered Case in the Hall of Biodiversity when it opened in 1998.

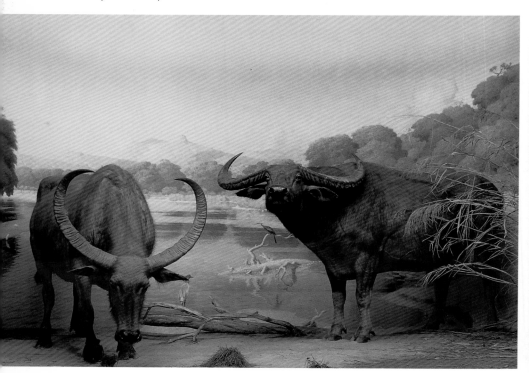

Water buffalo diorama

Culture Halls

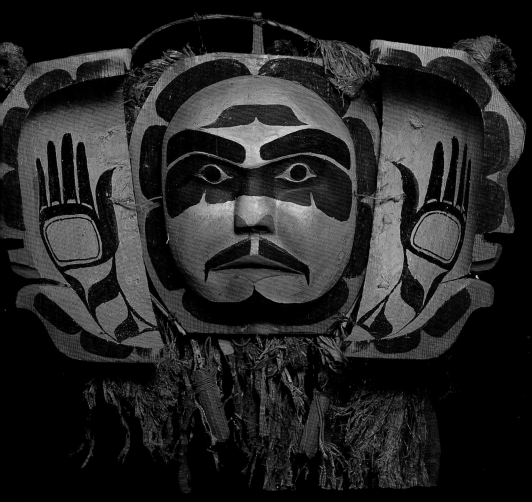

Kwakiutl two-faced mask

The American Museum of Natural History's Division of Anthropology includes many of the world's most respected anthropologists, who conduct research around the world and steward an extensive collection of cultural artifacts amassed over more than a century. The groundbreaking work of Margaret Mead, Franz Boas, and many other early Museum anthropologists has shed light upon the richness of human cultures past and present. The public face of the Division comprises a series of exhibition halls that explores the traditional cultures of Asia, Africa, North and South America, and the Pacific.

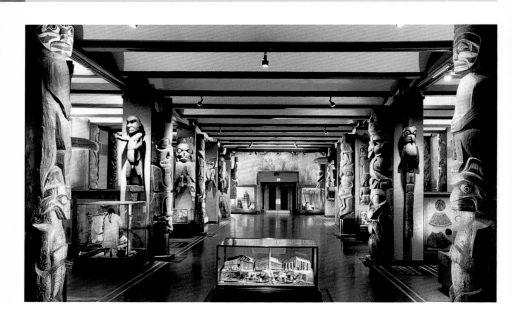

The Hall of Northwest Coast Indians, the Museum's oldest hall, showcases the research conducted during the Museum's first major field expedition, the Jesup North Pacific Expedition (1897–1902), considered one of the most important anthropological field studies ever made. Organized by Museum President Morris K. Jesup and led by Franz Boas (1858–1942), known as the "father of American anthropology," the expedition set out to investigate the cultural and biological links between people living on both sides of the Bering Strait, with the hope of determining whether or not America was first populated by migrations from Asia. The cultures featured in the hall occupy North America's shores from Washington State to southern Alaska. The artifacts, folklore, and artwork displayed document and celebrate the customs and artistry of the Kwakiutl, Haida, Tlingit, Bella Coola, and other peoples. Exhibits include exquisite totem carvings, clothing, tools, and masks.

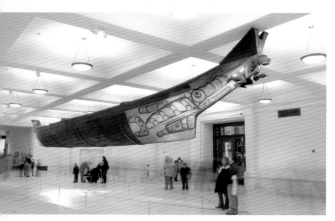

Haida canoe

These halls showcase artifacts such as cooking utensils, clothing, weapons, and jewelry from traditional Native American cultures in the East and in the Plains. The Hall of Eastern Woodlands Indians focuses on the traditional cultures of the Mohegan, Ojibwa, Cree, and other Native American peoples living in the Eastern Woodlands of North America. In addition to artifacts, this hall features models of Eastern Woodlands lodgings, from the wigwam of the Ojibwa to the longhouse of the Iroquois. The Hall of Plains Indians focuses on the cultures of the mid-19th-century Blackfeet, Hidatsa, Dakota (Sioux), and other peoples of the North American Plains, and is also home to one of the Museum's greatest treasures, the Folsom Point. This flint arrowhead, found near Folsom, New Mexico, in 1926, provides irrefutable evidence that there were humans in the Americas as early as the last ice age.

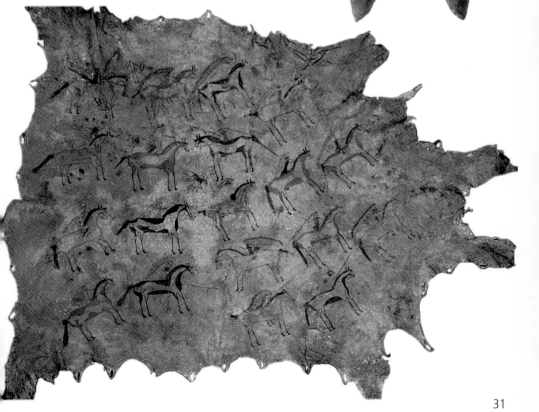

Folsom Point

Cheyenne narrative buffalo robe

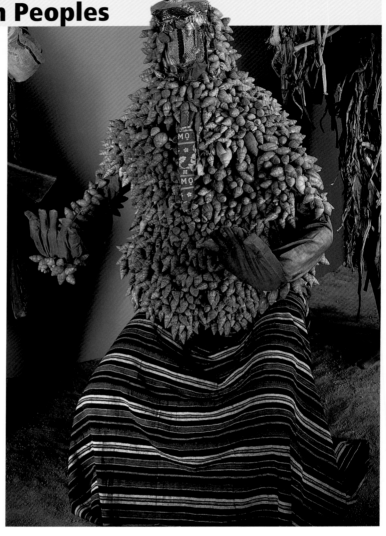

Costume of
Marikoto, a
Yoruba
ceremonial figure

Africa, a continent of nearly 12 million square miles and more than 700 million inhabitants, boasts a rich array of cultures. The Hall of African Peoples explores this great diversity, highlighting the traditional lifestyles and customs of people living in Africa's grasslands, deserts, forests, and river regions. The religious, political, economic, and domestic aspects of life are highlighted through artifacts and dioramas. On display are masks, musical instruments, farming tools, religious idols, ceremonial costumes, and more. Dioramas depict a variety of peoples, from the Berbers of the desert in North Africa to the Mbuti pygmies in the Congo. Also featured are the Yoruba, Pokot, and Bira, among others.

The Museum's holdings in Asian ethnology constitute one of the finest such collections in the Western Hemisphere. This extensive collection provides the foundation for the Hall of Asian Peoples, the Museum's largest cultural hall. The hall explores such topics as prehistoric Eurasia and the rise of civilization, early Asian cultures, and Asian trade, and includes such vastly different and diverse regions as Korea, China, India, Armenia, and Siberia. The hall also documents the rise of the great world religions of Buddhism, Christianity, Islam, Hinduism, and Confucianism. Highlights include the shaman diorama, which faithfully re-creates a late 19th-century healing ceremony of the Yakut of Eastern Siberia. The scene depicts a shaman who has come to heal a woman whose soul has been captured by evil spirits. Also featured in the hall is an ornate wedding chair, which would have carried a traditional Chinese bride to her new life with her husband's family. The chair is covered with auspicious symbols to invite good fortune.

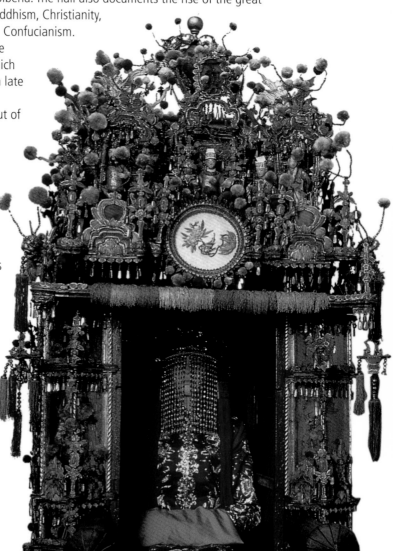

Chinese wedding chair

33

Mexico and Central America

The diverse art, architecture, and traditions of the Maya, Toltec, Olmec, Aztec, and other Mesoamerican pre-Columbian cultures are the subjects of this hall. The outstanding collections on display include monuments, figurines, pottery, and jewelry that span from around 1200 B.C. to the early 1500s. Each object provides clues about the political and religious symbols, social traits, and artistic styles of its cultural group. Especially striking works on view include Costa Rican gold ornaments and a 3,000-year-old Olmec jade sculpture called the Kunz Axe, which may represent a chief or a shaman who transformed himself into a jaguar to partake of the animal's power. Also displayed are ninth-century Mayan stone carvings depicting scenes of conquest. Existing as early as 1500 B.C., the Maya culture did not consist of a single empire, but rather was a collection of independent city-states that alternately warred and traded with one another.

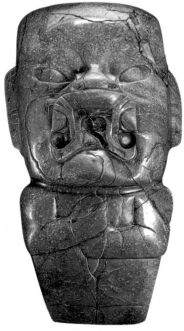

Kunz Axe

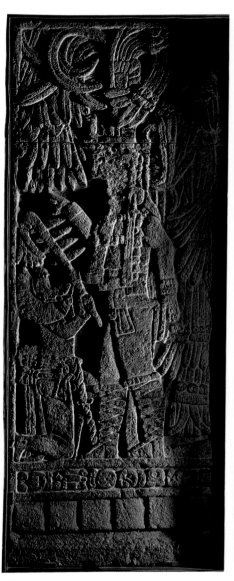

Mayan stone carving

HALL OF
South American Peoples

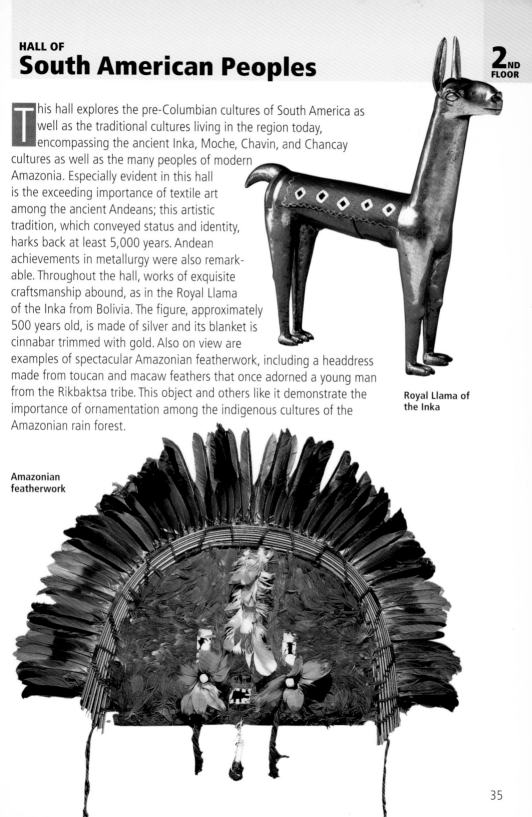

This hall explores the pre-Columbian cultures of South America as well as the traditional cultures living in the region today, encompassing the ancient Inka, Moche, Chavin, and Chancay cultures as well as the many peoples of modern Amazonia. Especially evident in this hall is the exceeding importance of textile art among the ancient Andeans; this artistic tradition, which conveyed status and identity, harks back at least 5,000 years. Andean achievements in metallurgy were also remarkable. Throughout the hall, works of exquisite craftsmanship abound, as in the Royal Llama of the Inka from Bolivia. The figure, approximately 500 years old, is made of silver and its blanket is cinnabar trimmed with gold. Also on view are examples of spectacular Amazonian featherwork, including a headdress made from toucan and macaw feathers that once adorned a young man from the Rikbaktsa tribe. This object and others like it demonstrate the importance of ornamentation among the indigenous cultures of the Amazonian rain forest.

Royal Llama of the Inka

Amazonian featherwork

The renowned anthropologist Margaret Mead (1901–1978) worked in the Museum's Anthropology Department from 1926 until her death. Through her groundbreaking expeditions to Samoa, New Guinea, and Bali, Mead brought anthropological work into the public consciousness. Her studies provide the foundation for the Hall of Pacific Peoples, which reflects a remarkable geographic and cultural diversity. The hall explores the cultures of the South Pacific islands, which range from tiny stretches of land to the island continent of Australia and include Polynesia, Micronesia, and Melanesia. Highlights include a display of elaborately painted and adorned dance masks from Northern New Ireland, part of Papua New Guinea. Made of wood and bark fibers, the masks represent specific spirits and are used in traditional dance ceremonies. Also on view are intricately detailed shadow puppets from Java. Originating in the 11th century, Javanese puppet theater is used as an educational tool to communicate information about religious tenets, moral codes, history, and myths.

Margaret Mead in Pere Village, Manus, New Guinea, 1965

New Ireland mask

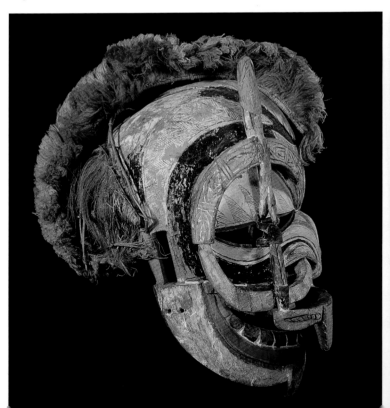

FREDERICK PHINEAS & SANDRA PRIEST

Rose Center for Earth and Space

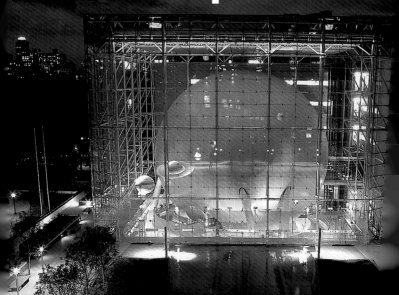

The opening of the Rose Center in February 2000 represented one of the most exciting chapters and most ambitious achievements in the Museum's long and distinguished history. In terms of sheer space alone, the monumental 120-foot-high, 333,500-square-foot facility increased the Museum's square footage by approximately 25 percent. It is a center for scientific research, a technological marvel, New York's latest architectural icon, and a powerful educational resource—in short, a singular facility that sets a new standard for museums and planetariums worldwide.

The Rose Center encompasses a completely rebuilt Hayden Planetarium and spectacular exhibition halls that explore the vast range of sizes in the cosmos; the more th... history of the univer... nature of galaxies, s... and the dynamic fea... unique planet Earth...

Not only has the received internatio... exhibits and state-... technology, it is als... of New York City's iconic architectura... striking design inc... glass curtain wall States, constructe... "water-white" gla... interior space wit... than that of Gran... Here the architec... science; the entir... created with an ... and inspiring vis...

DOROTHY AND LEWIS B. CULLMAN
Hall of the Universe

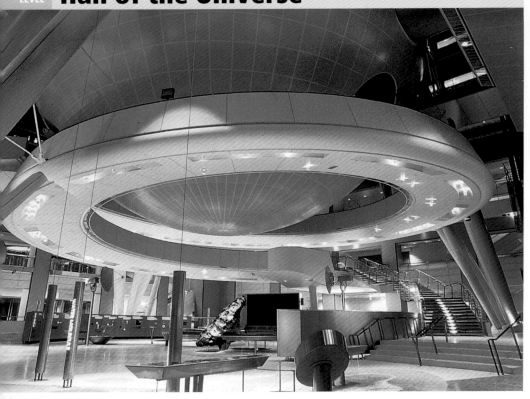

Below: **Visitors with a Teaching Volunteer in the Hall of the Universe**

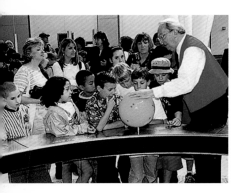

The Dorothy and Lewis B. Cullman Hall of the Universe presents the discoveries and explorations of modern astrophysics. This 7,000-square-foot hall is divided into four zones featuring exhibit islands rich with astronomical imagery, rotating video displays, computer interactives, and more.

The Universe Zone probes the limits of our powers of observation, while exploring the ways in which our universe is expanding. The Galaxies Zone celebrates the exquisite beauty and diversity of galaxies, while providing information on their formation and evolution. The Stars Zone links supernovae to the elements created by them, the chemical building blocks of our own human bodies, reinforcing the notion that we are made of "star stuff." The Planets Zone illustrates the formation and evolution of planets, with an examination of major meteorite collisions that have occurred on Earth, as well as possible future impacts.

Scales of the Universe

A major feature of the Rose Center is the Scales of the Universe exhibit along the 400-foot-long walkway that hugs the glass wall of the cube. This unique exhibit, which employs the facility's architectural features by using the Hayden Sphere as a basis for comparison, explores the vast range of sizes in the cosmos—from the observable

Visitors in the Scales of the Universe and on the Cosmic Pathway ramp

universe to our planet to a tiny electron. Along the walkway, stations introduce visitors, by increments of the power of ten, to the relative sizes of atoms, planets, stars, and galaxies, by using text panels, interactive terminals, and both large, overhead and small, rail-mounted models. Enormous, realistically rendered planets, stars, and galaxies—including a 9-foot-diameter model of Jupiter and a model of Saturn with 17-foot-diameter rings—are suspended from the ceiling of the building.

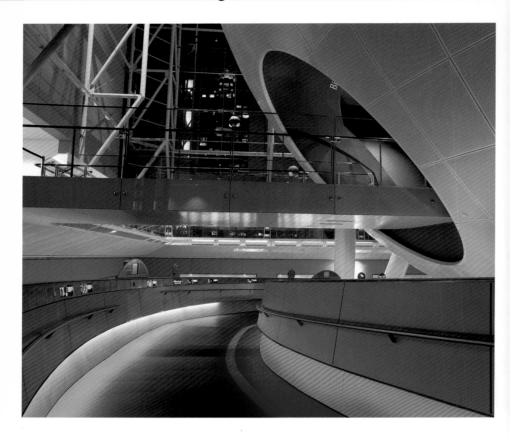

Following the explosive Big Bang experience, visitors exit onto the Harriet and Robert Heilbrunn Cosmic Pathway, a dramatic, spiraling ramp that ushers them through the billions of years of cosmic evolution. At the start of the walkway, visitors can measure the length of their stride and determine how many millions of years pass with each step. Markers along the way denote the passage of each billion years and, at eight landings, computer interactives help visitors understand the nature and size of the universe at that point in time. Artifacts are also on display, including evidence of the earliest bacterial life on Earth and the fossilized tooth of a giant carnivorous dinosaur. At the end of the 360-foot circular pathway, the thickness of a human hair illustrates the relative duration of human history, from cave paintings to the present day. The Heilbrunn Cosmic Pathway was specially designed to allow for adjustments and updates to the exhibitry, as research in astrophysics reveals new information about the age and nature of the universe.

Hayden Planetarium

Dominating the Rose Center is the magnificent Hayden Sphere, which features the world's largest virtual reality simulator. Weighing four million pounds and measuring 87 feet in diameter, the Hayden Sphere houses the Space Theater in its upper half and the Big Bang Theater in its lower hemisphere.

With the custom-made Zeiss Mark IX Star Projector and a Digital Dome Projection System, the 429-seat Space Theater displays a hyperrealistic view of the planets, star clusters, nebulae, and galaxies in an exhilarating journey from Earth to the edge of the observable universe. To create this virtual universe, a team of Museum scientists and visualization experts, along with colleagues from such organizations as NASA, worked in a remarkable collaboration of science, artistry, and advanced computing to "stitch together" images of our universe, based on astronomical observations and computer models. The Digital Universe is the most accurate and complete picture of our Milky Way Galaxy, a portrait that provides the foundation for the Hayden Planetarium Space Shows.

In the Big Bang Theater, visual and audio effects dramatically re-create how, according to scientists, the universe began with a burst of radiant energy from a point smaller than a grain of sand.

The Hayden Planetarium Space Theater showing the Orion Nebula

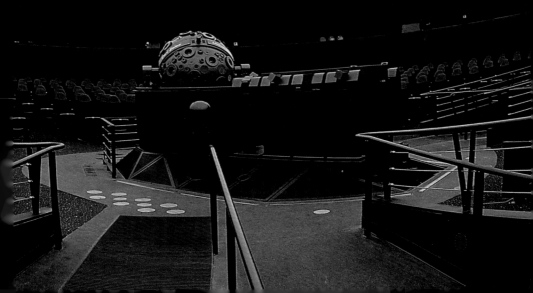

DAVID S. AND RUTH L. GOTTESMAN

Hall of Planet Earth

The David S. and Ruth L. Gottesman Hall of Planet Earth raises and explores key questions: How has the Earth evolved? Why are there ocean basins, continents, and mountains? How do we read the rocks? What causes climate and climate change? And, perhaps most significantly, why is Earth habitable?

The hall combines touchable rock specimens with computer interactives, video, and soundscapes to convey the power and beauty of planet Earth. Displayed is a stunning collection of 168 geological samples collected by Museum scientists in dozens of field expeditions to such places as Mount Vesuvius, the Grand Canyon, and the Swiss Alps. Together with 11 dramatic, full-scale models of significant outcrops and geological features, the specimens create a hall that is as beautiful and varied as Earth itself. The oldest specimen in the hall is a strikingly beautiful red-banded iron formation that is 2.7 billion years old. The "youngest" is a piece of bright yellow sulfur that was collected by Museum scientists just moments after it condensed from clouds of gas emitting from an Indonesian volcano. Other exhibits include the suspended eight-foot-diameter Dynamic Earth Globe, which creates an entrancing, changing view of the planet as seen from outer space. The electronic Earth Event Wall broadcasts reports of global events, such as earthquakes, volcanoes, and atmospheric conditions.

Mold makers applying latex to the cliff face of the Hutton Unconformity near Edinburgh, Scotland. The Museum used the mold to create a cast model for the Hall of Planet Earth.

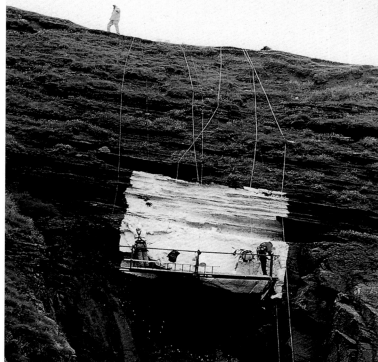

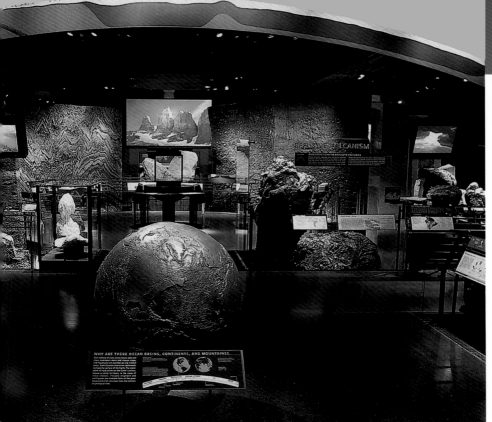

"Black Smokers"

Little known before the 1970s, "black smokers" are sulfide chimneys that form around hot springs in the deep ocean. The sulfide minerals precipitate when the scalding hot, mineral-laden water from deep within the earth comes in contact with the ice-cold sea. The submarine hot springs support a microbial community that does not live off sunlight but instead on the chemical energy of the earth. Some of the microbes that live on black smokers are considered the most ancient forms of life known on Earth and therefore hold clues to the development of life on Earth and the possibility of life elsewhere. The Museum, in collaboration with the University of Washington, conducted two groundbreaking expeditions

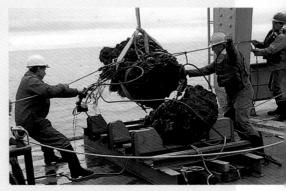

Engineers on the *Tully* hoisting a "black smoker" out of the Pacific Ocean off the coast of Washington

to study and collect black smokers for research and for their first-ever display, in the Gottesman Hall of Planet Earth.

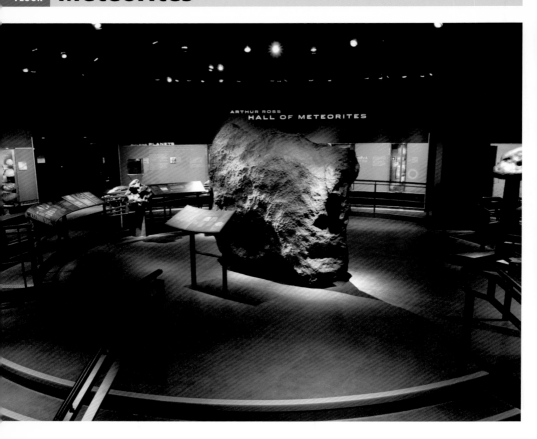

After an extensive renovation in 2003, the Arthur Ross Hall of Meteorites reopened with a new circular layout that sharpens the focus on its iconic centerpiece, a massive iron meteorite fragment called Ahnighito, the largest known piece of the Cape York meteorite. At 34 tons, Ahnighito is so massive that its supports go through the floor straight down to the bedrock of Manhattan. Ahnighito was brought to New York City from Cape York, Greenland, by explorer Commodore Robert E. Peary about 100 years ago, as were two smaller pieces of the same meteorite, known as the Woman and the Dog, which are also on display in the hall, forming a "family group." Meteorites provide a wealth of clues to the origins of our planet and solar system. Some carry samples of the primordial space dust from which our solar system was made. Meteorites from asteroids and other planets help scientists understand the formation and development of planets, and meteorite impacts have played an important role in many planets' histories, including Earth's.

HARRY FRANK GUGGENHEIM
HALL OF

MORGAN MEMORIAL
HALL OF

1ST
FLOOR

Minerals and Gems

These halls contain exquisite treasures, which can be systematically arranged according to their similarities and differences in the same manner as animals and plants. In the Hall of Minerals the visitor finds minerals composed of a single element, such as gold and copper, and groups that combine several elements, such as the silicates quartz, amethyst, and mica. The Hall of Gems displays groups of stones that showcase an extraordinary range of size, color, and shape. Among these specimens is the 563-carat Star of India, the largest and most famous star sapphire in the world. Formed some two billion years ago, the Star of India was discovered several centuries ago and donated to the Museum by J. P. Morgan in 1900. Also featured in the Hall of Gems is the Patricia Emerald, a 632-carat specimen that is one of the very few large, gem-quality emeralds that have been preserved uncut. The specimen is exceedingly rare not only because of its size and color, but also because of its dihexagonal, or twelve-sided, shape.

Patricia Emerald

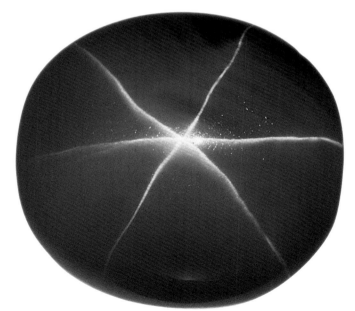

Star of India

45

The Spitzer Hall of Human Origins, opened in 2007, tells the sweeping story of humanity in the first major exhibition to present, side by side, the mutually reinforcing evidence of the fossil record and cutting-edge DNA research.

The hall covers millions of years of human history, from the emergence of our earliest ancestors six or seven million years ago through the evolution of our own species, *Homo sapiens*, some 150,000 years ago. Among the many full-size casts and reconstructions of important prehuman specimens are "Lucy," an *Australopithecus afarensis* that is more than 3 million years old; the 1.7-million-year-old "Turkana Boy;" and a fully articulated Neanderthal skeleton.

DNA is shown to be an invaluable tool for mapping hominid migrations, or for determining that our nearest living animal relatives, chimpanzees and bonobos, are 98.8 percent genetically identical to humans, who are, in turn, 99.9 percent genetically identical to each other. Here, too, a vial of extremely rare 40,000-year-old Neanderthal DNA is on public display for the first time.

With a fascinating mix of fossils, films, interactive media, life-size tableaux, ancient artifacts, and more, this hall also explores the origins of human creativity and its role in defining what it means to be human.

Life-size skeletons of a chimpanzee, a modern human, and a reconstructed Neanderthal

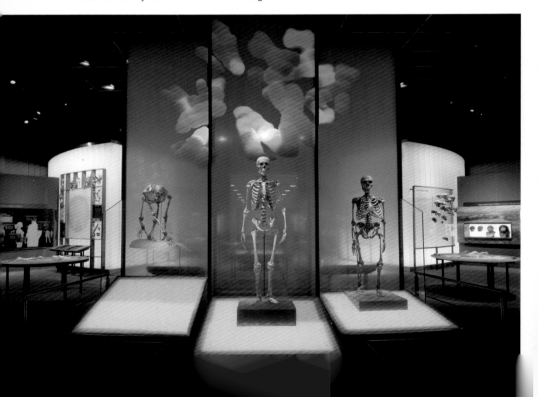

Biodiversity

The Hall of Biodiversity is a groundbreaking exhibition devoted to what many scientists believe is the most pressing environmental issue of our time: the need to protect and preserve our planet's biodiversity, the variety and interdependence of Earth's life forms. The 11,000-square-foot hall, which opened in 1998, represents an important step in the Museum's efforts to expand public understanding of Earth's diverse and often endangered life forms, while painting a vivid and inspiring portrait of the breathtaking beauty and abundance of life on Earth.

Visitors in the Central African Republic rain forest diorama

Dominating the hall is a spectacular diorama of the Dzanga-Sangha Rain Forest, which represents one of the most biodiversity-rich ecosystems on Earth. The diorama includes more than 160 species of flora and fauna and more than

Arthropod Collection

Arthropods, by almost any measure, are the most successful phylum on the planet. Including beetles as well as ants, crustaceans, spiders, mites, centipedes, and scorpions, Arthropoda accounts for over three-quarters of all currently known living and fossil organisms, though scientists suspect there are millions more species still undescribed. Of the Museum's collection of over 30 million specimens and cultural artifacts, its collection of arthropods is by far the largest—in fact it is one of the largest such collections in the world. The Museum holds 18 million arthropod specimens representing more than 300,000 species. Included is the world's most diverse collection of spiders (more than one million specimens) and termites, representing 100% of known species.

Biodiversity

500,000 leaves, each painstakingly made by hand. Representing a diorama "for the new millennium," the rain forest measures 90 feet long, 26 feet wide, and 18 feet high and invites visitors behind the glass into an immersive environment where high-resolution imagery, video, sound, and smell work together to create a habitat. The rain forest is depicted in three different states: pristine, altered by natural forces, and degraded by human intervention.

Another major element of the hall is the Spectrum of Life, the only exhibit of its kind in the world, showcasing the glorious diversity of life resulting from 3.5 billion years of evolution. Organized into 28 groups along a 100-foot-long installation are more than 1,500 specimens and models—microorganisms and mammals, bacteria and beetles, fungi and fish.

Center for Biodiversity and Conservation

Scientists at the American Museum of Natural History are in the forefront of research on the world's species, working to understand biodiversity through knowledge of the organization, geographic distribution, and history of Earth's species. Such knowledge is essential to stemming the tide of extinction and ensuring the welfare of the biosphere. In 1993, in response to heightened international awareness of the importance of biodiversity, the Museum established the interdisciplinary Center for Biodiversity and Conservation. Dedicated to applying rigorous science to conservation efforts, the CBC forges key partnerships to conduct conservation-related field projects around the world, trains scientists, organizes scientific conferences, presents public programs, and produces publications geared toward scientists, policy makers, and the lay public. The CBC's Conservation Genetics Program, in collaboration with the Wildlife Conservation Society, applies molecular genetic technology to biodiversity conservation efforts. Two current projects include advising the government of Vietnam on the designation of new protected areas and working in Bolivia to develop management plans for existing protected areas.

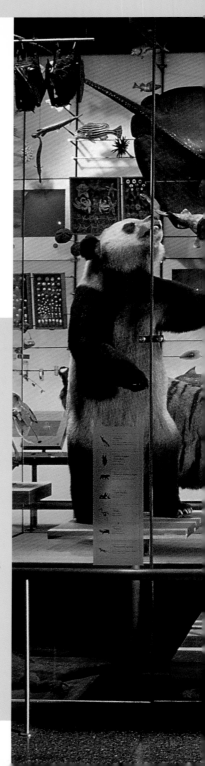

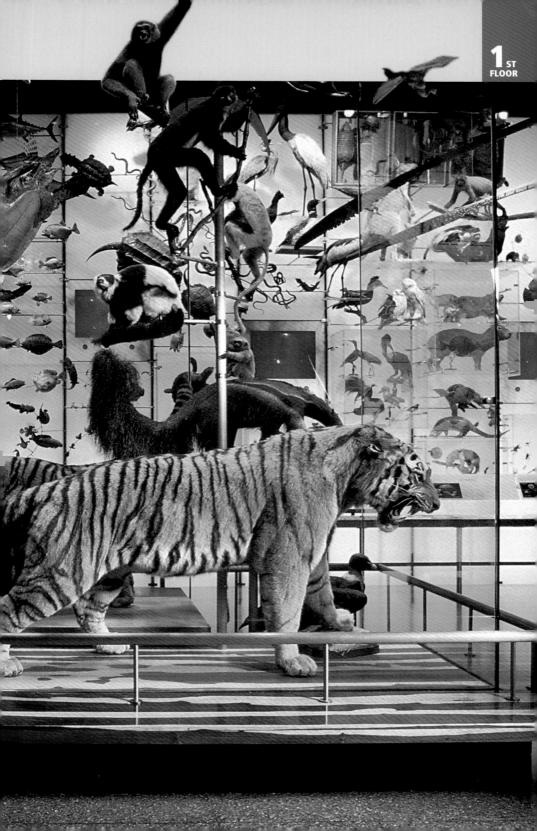

Ocean Life

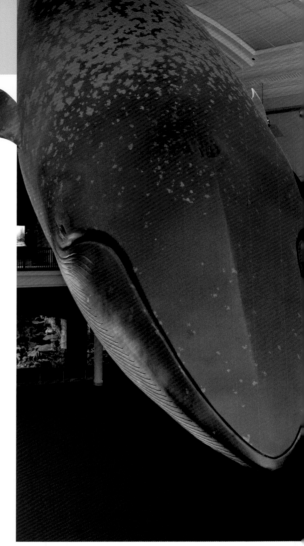

The Milstein Hall of Ocean Life reopened in 2003 after a total renovation, its first in over 30 years. The hall is still dominated by the famous blue whale model, one of the Museum's star attractions, which now floats in a "virtual ocean" created through dramatic lighting, video, and sound effects. The whale has been modified to reflect current scientific knowledge—her eyes and flukes have been adjusted, she received a new coat of paint to match the color of a live whale, and a six-inch navel has been added. The 29,000-square-foot hall is now a fully immersive marine environment with high-definition video projections, interactive computer stations, and eight new ocean habitat displays. The skylights above the whale have been fitted with shimmering blue lights to emulate undulating waves, enhancing the impression of being submerged in the depths of the sea.

Blue whale model

The Andros Coral Reef Diorama

The Andros coral reef diorama, created in 1935 and completely restored in 2003, contains 40 tons of coral collected near Andros Island in The Bahamas. The only two-level diorama in North America, it allows an "above-and-below" view of this ecosystem that is not possible in real life. The lower-level re-creation of the abundant sea life is complemented by the mezzanine-level depiction of life above the water's surface and enriched by the background mural with its swaying palm trees and the Bahamian sea and sky.

HALL OF
North American Forests

This hall exploring the ecology of North American forests features a piece of a giant sequoia tree. The sequoia, which was cut down in 1891, had survived for more than 1,300 years and its full height exceeded 300 feet. Around the central point of the tree slice are concentric rings, some of which are invisible to the naked eye; each of these represents one year's growth. Conveying the immense age of the tree are markers on some of the growth rings corresponding to significant historical events, such as Charlemagne being crowned Holy Roman Emperor (A.D. 800).

Traveling through scale rather than time, a diorama of the forest floor represents a cross section of the soil, enlarged to 24 times its actual size. This scene demonstrates the process of decomposition, by which natural debris is broken down into new substances, which exist in the soil as nutrients. While bacteria and fungi help break the debris down, so do some of the creatures re-created in the diorama.

Giant sequoia

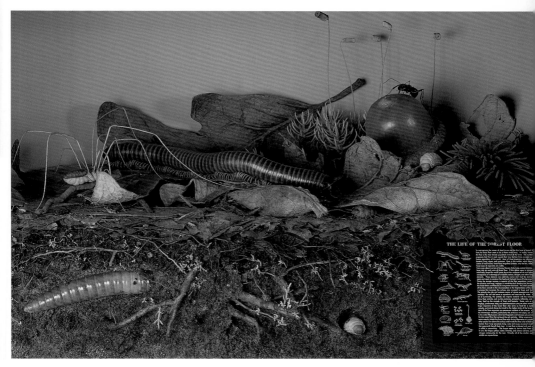

Forest floor diorama

The primate order, one of the many subdivisions of mammals, includes monkeys, apes, and humans. This hall provides an overview of primates through skeletons, mounted specimens, and artwork. The order is broken down into families, in displays that trace both their shared characteristics and those unique to each group, demonstrating a fascinating variety of animals. Primates range in size from the pygmy marmoset to the orangutan and gorilla, and include species such as tree shrews that more closely resemble rodents. While the apes, which are specialized for swinging by their hands, do not have tails, many primates such as spider monkeys have long tails they use for grasping. Some species live predominantly among the trees while others inhabit the forest floor, and primates' habitats are found from South America to Southeast Asia to Africa. The visitor can explore the relationship of hominids, or humans, to other primates through these characteristics and others, including posture, the amount of body hair, and the shape of the hand and especially the thumb.

Potto, a relative of the lemur

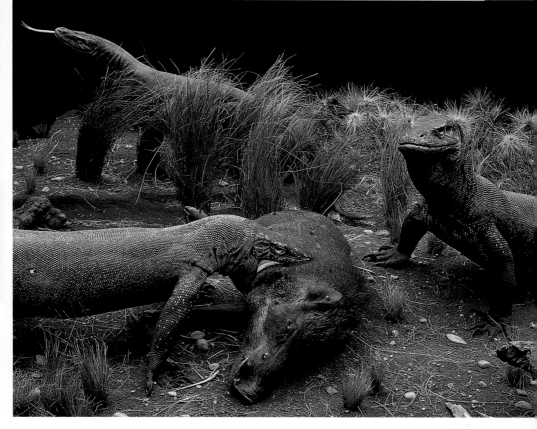

This hall explores the fascinating features of reptiles and amphibians, arranging them into such themes as anatomy, defense, locomotion, distribution, reproduction, and feeding. The visitor can view the great range of these animals' physical forms, from the tiniest toad to the fearsome crocodile, and the widely diverse ways in which they move, protect themselves, chase prey, and reproduce. Exhibits include the leatherback sea turtle laying its eggs in the sand, the Australian frilled lizard raising its frill of skin to exaggerate its size to a predator, and the Komodo dragon stretching its jaws across the belly of a wild boar. Komodo dragons are especially impressive for their great size and their rarity. These ferocious hunters, which can grow to a length of ten feet and weigh as much as 200 pounds, are found in Indonesia and are endangered. While these reptiles, the largest lizards on Earth, are now being bred in captivity, their continued existence in the wild depends on the maintenance of their native habitat.

Komodo dragon

Bird Halls

The Museum has several halls dedicated to birds, ranging from the local (New York City Birds) to the regional (North American Birds) to the global (Birds of the World). In addition, the Whitney Memorial Hall of Oceanic Birds features the bird populations of the Pacific and the southern polar seas. Together these halls portray the wide variety of avian life on the planet, as well as the vastly diverse locations that birds inhabit.

The Leonard C. Sanford Hall of North American Birds showcases dioramas conceived by the Museum's renowned ornithologist Frank M. Chapman (1864–1945), a leader in the study of bird speciation and distribution in the Western Hemisphere. Under his direction, the Museum's bird collection grew to become one of the greatest in the world and now holds 99 percent of all known species. The peregrine falcon diorama in this hall re-creates a scene Chapman actually saw on the Hudson River Palisades: it shows an adult arriving at a nest site with a newly caught pigeon.

Birds represented in other halls include the now-extinct passenger pigeon, in the Hall of New York City Birds; Andean condors, in the Hall of Birds of the World; and pelicans, in the Hall of Oceanic Birds.

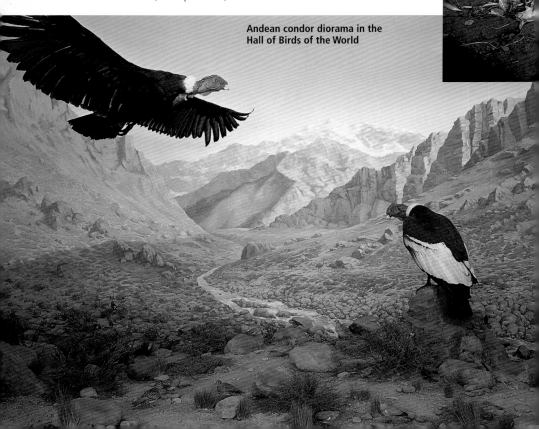

Andean condor diorama in the Hall of Birds of the World

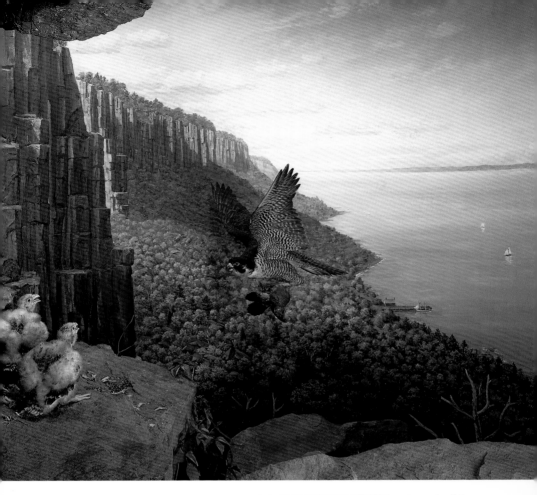

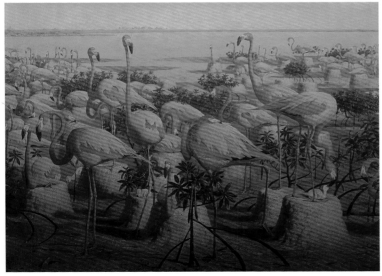

Peregrine falcon diorama (*above*) and flamingo mural (*left*) in the Sanford Hall of North American Birds

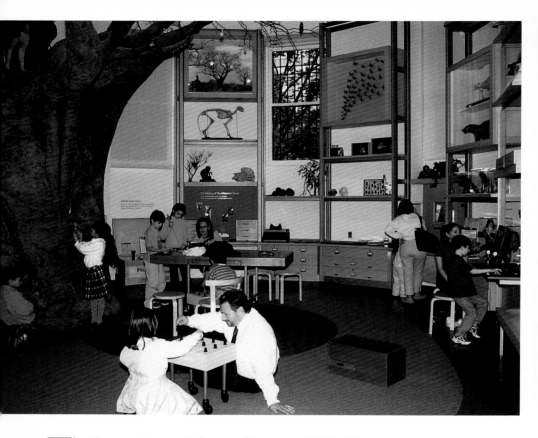

The Discovery Room, which opened in summer 2001, offers an inviting and fun gateway to the Museum for children and families. A range of experiences and hands-on activities lets kids interact with real specimens and artifacts and make their own collections and exhibits. Visitors can explore a field expedition chest and participate in a dinosaur dig, learn how cultural artifacts tell stories and then tell their own tales, discover how exhibits are made, and create their own "cabinet of curiosities." Key features for exploration are the African baobab tree ecosystem; the macroscope, a powerful microscope that projects onto a video screen; cultural artifacts from around the world that reflect traditional and contemporary points of view, such as a totem pole carved at the Museum in 1992 by the Kwakiutl artist Richard Hunt; and a full-size fossil cast of the reptile *Prestosuchus*, which can be taken apart and put back together. Hidden throughout the room are treasures and surprises just waiting to be discovered.

Visitors exploring the Discovery Room

Research Library

The Research Library of the American Museum of Natural History houses one of the world's finest collections of natural history research materials in the Western Hemisphere. With collections containing more than 450,000 volumes, over half a million photographs, 4,000 periodicals, 2,000 archival films and videos, and 13,000 rare books, the Library supports the scientific work of the Museum and provides an invaluable resource to the international scientific and scholarly community, including students and interested members of the public. Major topics covered in the collection are zoology, geology and mineral sciences, paleontology, anthropology, astronomy, and the history of science. The collection is particularly outstanding for its resources in zoological systematics.

The Library's Reading Room

The Library maintains copies of all of the Museum's past and present publications, both scientific and general, including: *Anthropological Papers of the American Museum of Natural History*; *American Museum Novitates*; *Bulletin of the American Museum of Natural History*; Micropaleontology Press publications; *Natural History* magazine; and *Curator*.

In 1999, the Museum was awarded a grant from the Andrew W. Mellon Foundation to digitize selected materials from the Library's collection. The new Digital Library enables scientists, scholars, and the public to access an integrated database of the Museum's Library resources and natural history collections at http://library.amnh.org.

Field journals from Museum expeditions

General Information

Hours
Daily, 10:00 a.m.–5:45 p.m.
The Museum is closed Thanksgiving and Christmas.

Checkrooms
Coats, umbrellas, and bags may be checked in the Theodore Roosevelt Rotunda (second floor) and in the Rose Center (lower level) for a nominal fee.

Tours
Highlights Tours, which provide an overview of the Museum's exhibition halls, are offered daily in English. The Museum also offers Spotlight Tours, which focus on specific areas or themes, and Highlights Tours in selected foreign languages. Please inquire at the Information Desks.

Shops
The Museum Shop (first and second floors, adjacent to Theodore Roosevelt Rotunda)
A spectacular triplex space features a variety of merchandise from around the world that reflects the Museum's exhibitions of human cultures, the natural world, and the universe. In addition to gifts, jewelry, accessories, and toys, the Shop includes the Book Mezzanine, which offers New York City's most comprehensive selection of natural-history-related books, tapes, and CDs.
Dinostore and More (fourth floor)
Dinosaur-related items and logo merchandise for children and adults
Planetarium Shop (lower level, Rose Center)
Merchandise related to space themes, including gifts and scientific instruments
Cosmic Shop (second floor, Rose Center)
Children's toys and games featuring space and Earth themes

Shops often accompany special exhibitions.
Also shop online at www.amnh.org.

Food Service
Menu selections and hours subject to change
Museum Food Court (lower level, across from the subway entrance)
This state-of-the-art café offers a wide variety of foods appealing to all ages and palates. Selections include stone oven pizza, sushi, grilled sandwiches, salad, and antipasti bar. Smoothies, desserts, snacks, fruits, ice cream, espresso, and beverages fill the bill. Food service customers wishing to pay with a credit card may do so at this location only.
Daily, 11:00 a.m.–4:45 p.m.
Café on 4 (fourth floor, adjacent to 77th Street elevators)
Overlooking the grounds at 77th Street from its windowed setting, Café on 4 offers sandwiches, salads, fruits, ice cream, desserts, espresso, and cold beverages.
Saturday and Sunday, 11:00 a.m.–4:45 p.m.; other hours as posted
Café on 1 (first floor, Grand Gallery)
This gourmet café offers snacks, salads, sandwiches, fruits, pastries, ice cream, and beverages.
Saturday and Sunday, 11:00 a.m.–4:45 p.m.; other hours as posted

Big Dipper Ice Cream Café (lower level, near the subway entrance)
This seasonal café offers classic ice-cream parlor treats, from cones to ice cream sodas, shakes, and malteds, in addition to cookies, brownies, and hot and cold beverages.
Seasonal hours

Accessibility
The 77th Street, Rose Center, and parking garage entrances are handicapped accessible. Wheelchairs are available upon request at handicapped-accessible entrances on a first-come, first-served basis. All public areas are accessible to wheelchairs; all video displays are captioned; and infrared assistive listening devices are available upon request in theaters.

Photography
Photography for personal use is allowed with handheld cameras (except where noted) and with available light or electronic flash attachments. Tripods and lights may not be used. Reproduction or sale of photographs is not allowed without permission. Photography is not allowed in the Space Theater or the LeFrak IMAX® Theater.

Transportation
Subway: B (weekdays) or C to 81st Street; 1 to 79th Street
Bus: M7, M10, M11, or M104 to 79th Street; M79 to Central Park West
Parking: A three-story parking garage is open daily during Museum operating hours; enter from West 81st Street.

Membership
Museum Membership offers many benefits and privileges, and helps support scientific research, education, and exhibitions at the Museum. To join, or for more information, stop by the Membership desks, call 212-769-5606, or visit www.amnh.org.

Information and Tickets
For information, call 212-769-5100.
To purchase advance tickets to the Museum, Space Shows, *SonicVision*, IMAX® movies, or special exhibitions, or to make reservations for programs, call 212-769-5200 or visit www.amnh.org.

www.amnh.org
Visit the Museum's Web site to learn more about exhibitions, programs, and research, to purchase tickets and shop merchandise, and to become a Member.

The American Museum of Natural History is a private not-for-profit educational institution supported by admission fees, membership, and contributions. The City of New York owns the Museum buildings and the land on which they sit and provides funds for their operation and maintenance.

AMERICAN MUSEUM ᴼF NATURAL HISTORY

Central Park West at 79th Street, New York, New York

Floor Plans
LOWER LEVEL

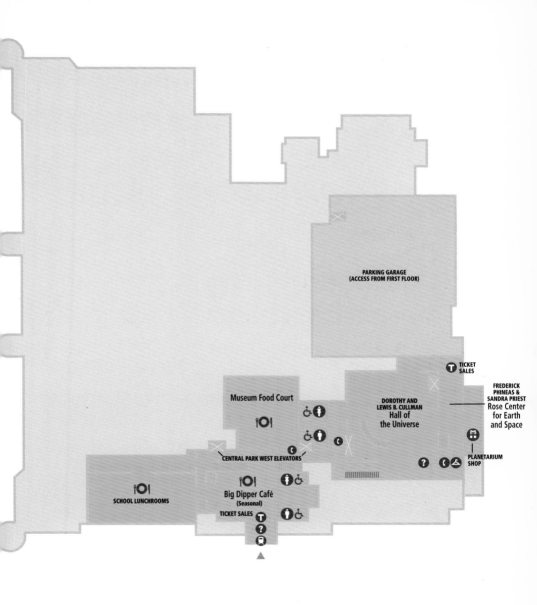

PARKING GARAGE
(ACCESS FROM FIRST FLOOR)

TICKET SALES

Museum Food Court

DOROTHY AND
LEWIS B. CULLMAN
Hall of
the Universe

FREDERICK
PHINEAS &
SANDRA PRIEST
Rose Center
for Earth
and Space

CENTRAL PARK WEST ELEVATORS

PLANETARIUM
SHOP

SCHOOL LUNCHROOMS

Big Dipper Café
(Seasonal)

TICKET SALES

Museum Entrance

Subway Entrance

Wheelchair Accessible

Women's Restrooms

Men's Restrooms

Stairs

Escalator

Elevator

Ticket Sales

Information Desk

Restaurant

Museum Shop

Telephone

Automated Teller Machine

ARTHUR ROSS Hall of Meteorites

HARRY FRANK GUGGENHEIM Hall of Minerals

MORGAN MEMORIAL Hall of Gems

JUDY AND JOSH Weston Pavilion

COLUMBUS AVENUE ENTRANCE

ANNE AND BERNARD SPITZER Hall of Human Origins

HENRY KAUFMANN Theater

CHARLES A. DANA Education Wing

HAROLD F. LINDER Theater

Café on 1

77th STREET ENTRANCE (Evening programs only)

ENTRANCE
SCHOOL GROUP CHECK-IN
PARKING GARAGE

Northwest Coast Indians

SAMUEL J. AND ETHEL LEFRAK IMAX Theater

TICKET SALES

TICKET SALES

SPECIAL EXHIBITION Gallery 77

Small Mammals

ENTRANCE
SATELLITE SHOP

Discovery Room

77TH STREET ELEVATORS

MILSTEIN Hall of Ocean Life

THE MUSEUM SHOP

North American Mammals

Rose Gallery

INFORMATION, GROUP TICKETS, AND WILL CALL

FELIX M. WARBURG MEMORIAL Hall of New York State Environment

Space Show Boarding

81st STREET ENTRANCE

FREDERICK PHINEAS & SANDRA PRIEST Rose Center for Earth and Space

North American Forests

Hall of Biodiversity

CENTRAL PARK WEST ELEVATORS

Theodore Roosevelt Memorial Hall

DAVID S. AND RUTH L. GOTTESMAN Hall of Planet Earth

TICKET SALES

SECURITY OFFICE

CENTRAL PARK WEST ENTRANCE

- ▲ Museum Entrance
- Subway Entrance
- Wheelchair Accessible
- Women's Restrooms
- Men's Restrooms
- Stairs
- Escalator
- Elevator
- Ticket Sales
- Information Desk
- Restaurant
- Museum Shop
- Telephone
- Automated Teller Machine

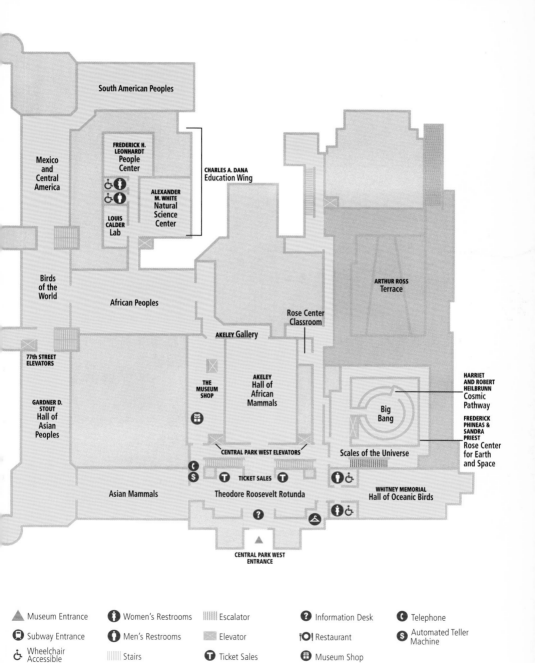

South American Peoples

Mexico and Central America

FREDERICK H. LEONHARDT **People Center**

CHARLES A. DANA **Education Wing**

ALEXANDER M. WHITE **Natural Science Center**

LOUIS CALDER **Lab**

Birds of the World

African Peoples

ARTHUR ROSS Terrace

Rose Center Classroom

AKELEY Gallery

77th STREET ELEVATORS

THE **MUSEUM SHOP**

AKELEY Hall of African Mammals

HARRIET AND ROBERT HEILBRUNN **Cosmic Pathway**

Big Bang

GARDNER D. STOUT **Hall of Asian Peoples**

FREDERICK PHINEAS & SANDRA PRIEST **Rose Center for Earth and Space**

CENTRAL PARK WEST ELEVATORS

Scales of the Universe

Asian Mammals

TICKET SALES

Theodore Roosevelt Rotunda

WHITNEY MEMORIAL **Hall of Oceanic Birds**

CENTRAL PARK WEST ENTRANCE

🔺 Museum Entrance	🚺 Women's Restrooms	▦ Escalator
Ⓢ Subway Entrance	🚹 Men's Restrooms	⬛ Elevator
♿ Wheelchair Accessible	▦ Stairs	🎫 Ticket Sales

❓ Information Desk	Ⓒ Telephone
🍴 Restaurant	Ⓢ Automated Teller Machine
🏛 Museum Shop	

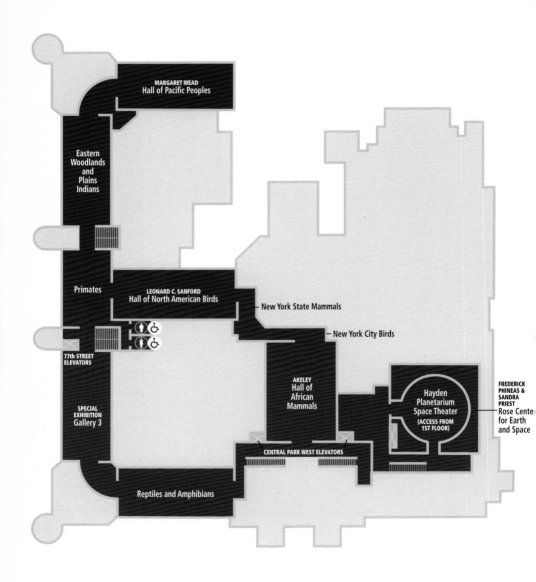

MARGARET MEAD
Hall of Pacific Peoples

Eastern
Woodlands
and
Plains
Indians

Primates

LEONARD C. SANFORD
Hall of North American Birds

— New York State Mammals

— New York City Birds

77th STREET
ELEVATORS

AKELEY
Hall of
African
Mammals

Hayden
Planetarium
Space Theater
(ACCESS FROM
1ST FLOOR)

FREDERICK
PHINEAS &
SANDRA
PRIEST
Rose Center
for Earth
and Space

SPECIAL
EXHIBITION
Gallery 3

CENTRAL PARK WEST ELEVATORS

Reptiles and Amphibians

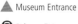

▲ Museum Entrance	🛈 Women's Restrooms	▥ Escalator	❓ Information Desk	📞 Telephone
🚇 Subway Entrance	🛈 Men's Restrooms	✉ Elevator	🍴 Restaurant	💲 Automated Teller Machine
♿ Wheelchair Accessible	▥ Stairs	🎫 Ticket Sales	🏛 Museum Shop	

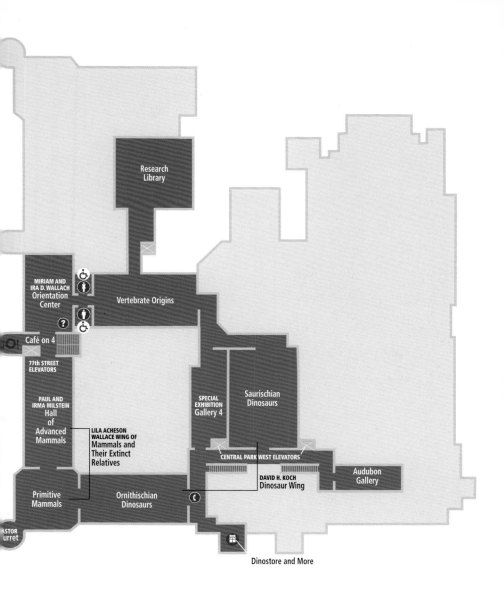

Research
Library

MIRIAM AND
IRA D. WALLACH
Orientation
Center

Vertebrate Origins

Café on 4

77th STREET
ELEVATORS

PAUL AND
IRMA MILSTEIN
Hall
of
Advanced
Mammals

LILA ACHESON
WALLACE WING OF
Mammals and
Their Extinct
Relatives

SPECIAL
EXHIBITION
Gallery 4

Saurischian
Dinosaurs

CENTRAL PARK WEST ELEVATORS

DAVID H. KOCH
Dinosaur Wing

Audubon
Gallery

Primitive
Mammals

Ornithischian
Dinosaurs

ASTOR
urret

Dinostore and More

▲ Museum Entrance	🚺 Women's Restrooms	‖‖‖ Escalator	❷ Information Desk	☏ Telephone
🚇 Subway Entrance	🚹 Men's Restrooms	▨ Elevator	🍴 Restaurant	$ Automated Teller Machine
♿ Wheelchair Accessible	‖‖‖ Stairs	🎫 Ticket Sales	🏛 Museum Shop	

Index Numbers in bold refer to illustrations